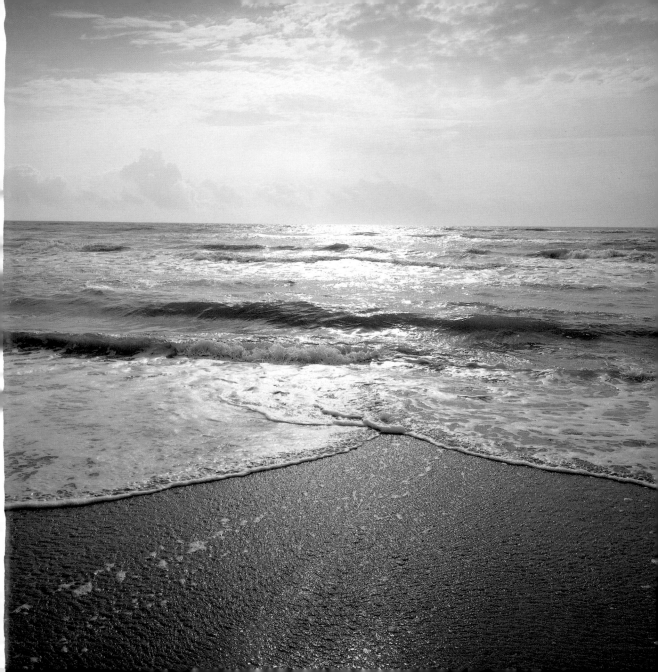

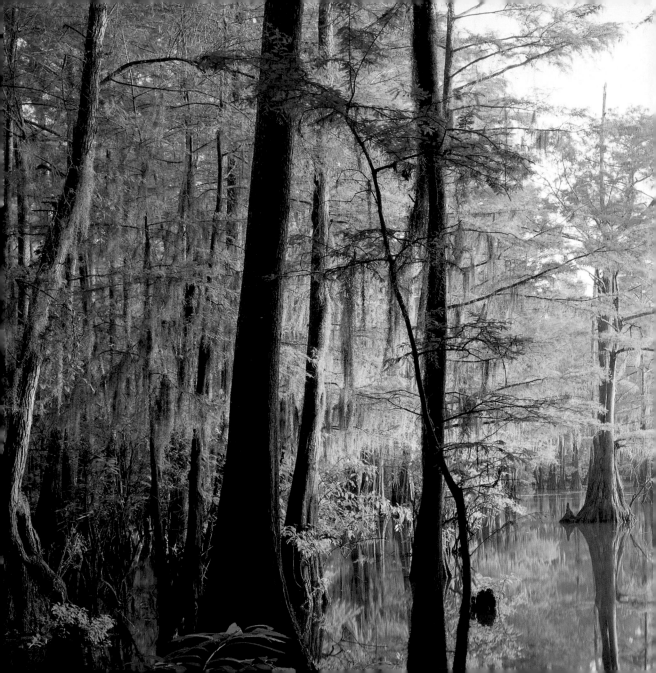

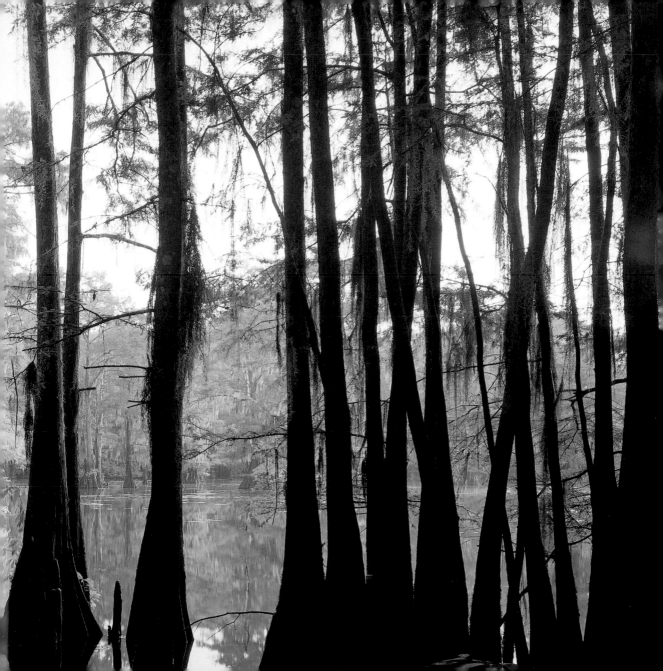

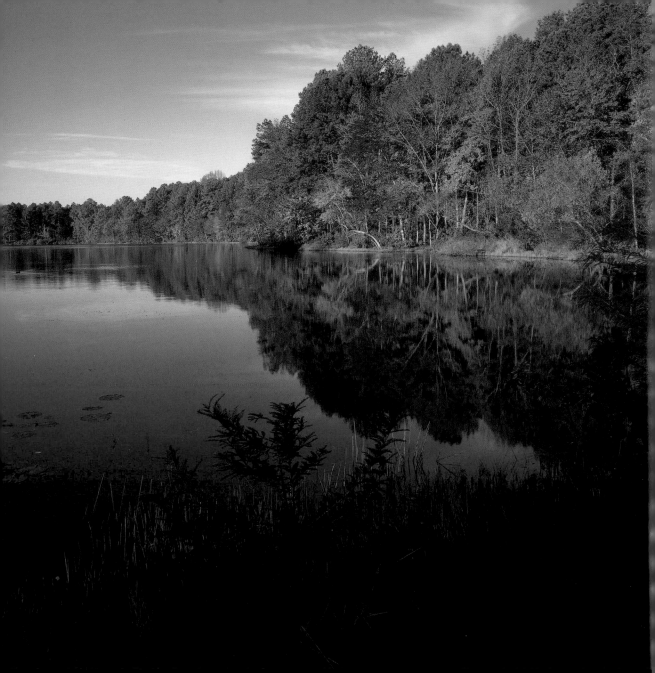

# TEXAS REFLECTIONS

Photography by Richard Reynolds
With Selected Prose & Poetry

*Texas Littlebooks*

Westcliffe Publishers, Inc., Englewood, Colorado

First frontispiece:  Morning light, Padre Island National Seashore
Second frontispiece:  Cypress trees, Caddo Lake State Park
Third frontispiece:  Autumn reflections, Daingerfield State Park
Opposite:  Lily pads, Daingerfield State Park

International Standard Book Number: 1-56579-144-4
Library of Congress Catalog Number: 95-62423
Copyright Richard Reynolds, 1996. All rights reserved.
Published by Westcliffe Publishers, Inc.
2650 South Zuni Street, Englewood, Colorado  80110
Publisher, John Fielder; Editor, Suzanne Venino; Designer, Amy Duenkel
Printed in Hong Kong by Palace Press

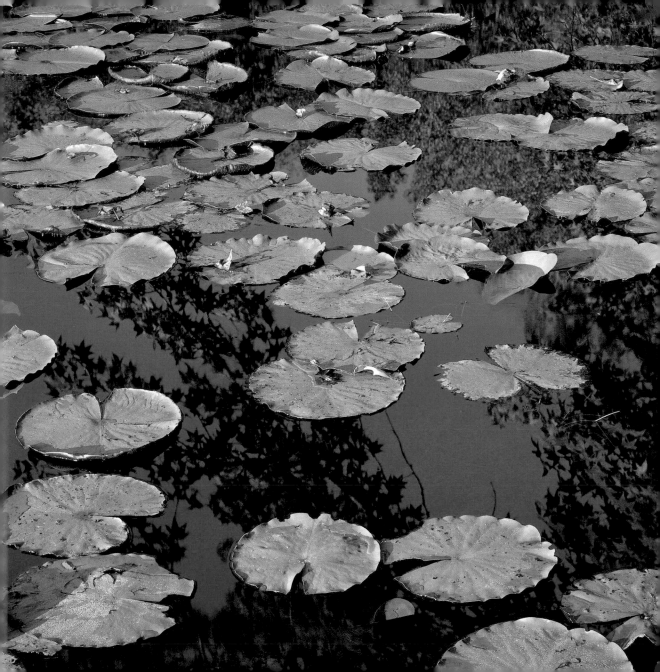

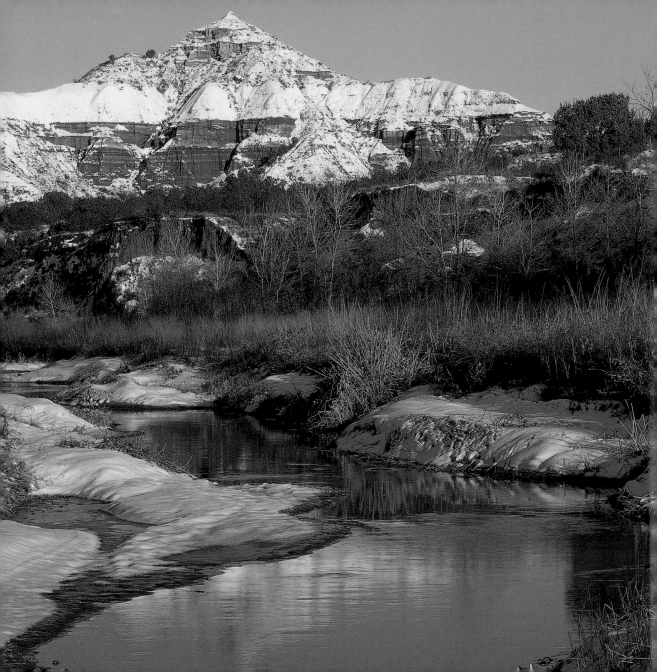

# PREFACE

If there is an ingredient I find myself needing when I am trying to make a successful photograph, it is usually a good foreground. Many potentially great landscape photographs too often lack depth and scale because there isn't something in the foreground to lead the viewer into the scene.

I often include a cactus, a flowering plant, or an interesting geological feature in my images to add visual interest and bring the subject right up to the viewer. Perhaps one of the best foregrounds of all is water. Because of its reflective qualities, it can immediately bring additional color into the photograph and add another dimension to it.

Depending on whether the water is still or moving, the reflected image can be mirror-sharp, softly diffused, or, in the case of fast-flowing rivers and streams, so diffused that it is impossible to identify what is being reflected.

Perfectly still conditions are usually found right before sunrise and right after sunset, when the sun ceases to stir up the atmosphere with its heat. In these situations, the reflected image can be as sharp and clear as the scene itself, and if the photograph is turned upside down, it is difficult to tell what is real and what is the reflection. (The give-away is in the darker rendition of the reflected image.)

Sunrise and sunset are also good times to photograph reflections because of intense, color-saturated light that is characteristic of these times of the day. And, of course, shots of the sun setting or rising over water are spectacular as well.

Another visually interesting situation occurs when fish, feeding on insects on the water's surface, cause patterns of concentric circles, resulting in yet another abstraction of shapes and colors.

Many locations in Texas, such as the Panhandle or the Gulf Coast almost never experience calm conditions. Diffuse reflections have their own charm and beauty, however,

Capitol Peak, Palo Duro Canyon State Park

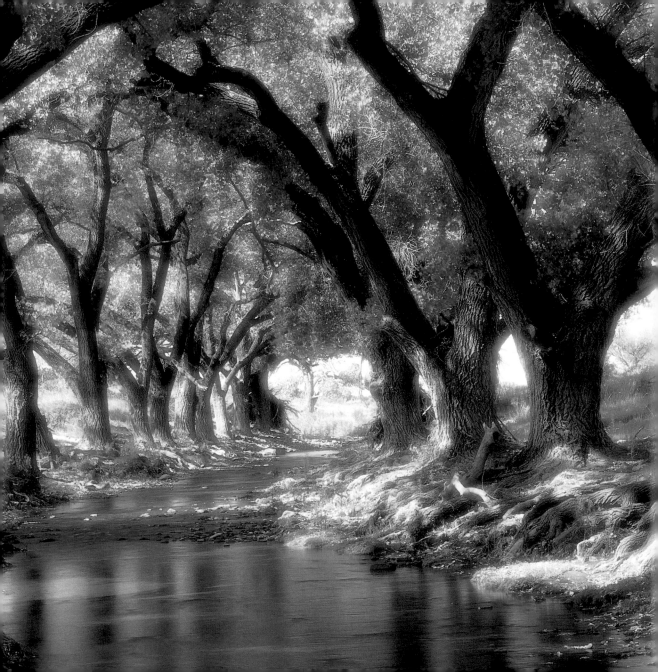

often rendering an impressionistic effect, which I happen to like. (Ansel Adams once advised me, after viewing some of my "fuzzy" and muted photographic renderings, to leave impressionism to the Impressionists. This deterred me from making any more such images for many years!)

Photographs of lakes and ponds that have trees or other objects breaking the surface can also be very interesting. I was photographing lily pads on Lake Daingerfield in eastern Texas once when I noticed that the water between the pads was reflecting a few fleecy white clouds in the cobalt-blue sky, lending to the scene an almost surreal quality and conveying an unusual sense of depth.

On another day a few years ago, I was at Caddo Lake in northeast Texas, photographing bald cypress trees whose needles had been transformed into a beautiful red-orange color brought on by the cooler and shorter days of autumn. Photographing swamps can be difficult because the water tends to be rendered jet-black on color film. This often conveys a scary quality that may not be what the photographer wants. In this case, I didn't want that either, so I repositioned the camera angle to catch the reflection of the blue sky on the otherwise colorless surface of the water, resulting in a much more pleasing depiction of the swamp environment.

The sound, sight, and feel of water have always had a calming effect on humans, and experiencing its healing powers has been an age-old pastime for people trying to clarify their thoughts and make sense of an often confusing world. I sincerely hope that these images of reflections in wild Texas settings will kindle in you an appreciation for the natural world, and, perhaps, help you to unload some of the burdens of daily life.

—Richard Reynolds
Austin, Texas

Cottonwoods along Limpia Creek, Davis Mountains

"It is the marriage of the soul with Nature that
makes the intellect fruitful, and gives birth
to the imagination."

— Henry David Thoreau, *Journal*

Sunrise, South Padre Island

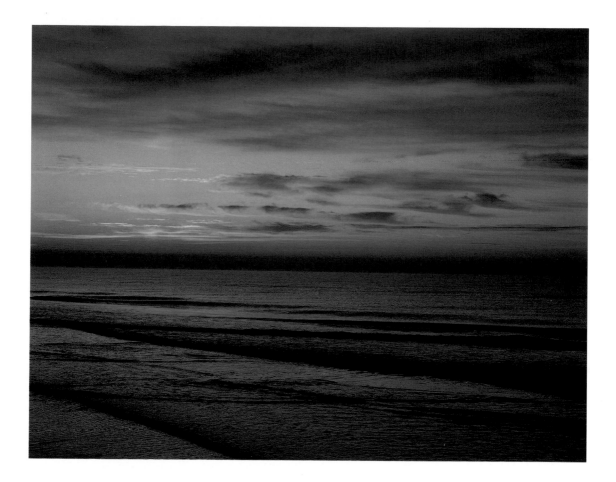

"The day, water, sun, moon, night — I do not have to purchase these things with money."

— Titus Maccius Plautus, *The Comedy of Asses*

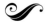

Pedernales River, Pedernales Falls State Park

"Nature is an endless combination and repetition of
a very few laws. She hums the old well-known air through
innumerable variations."

— Ralph Waldo Emerson, *Essays*

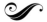

Summer morning, Daingerfield State Park

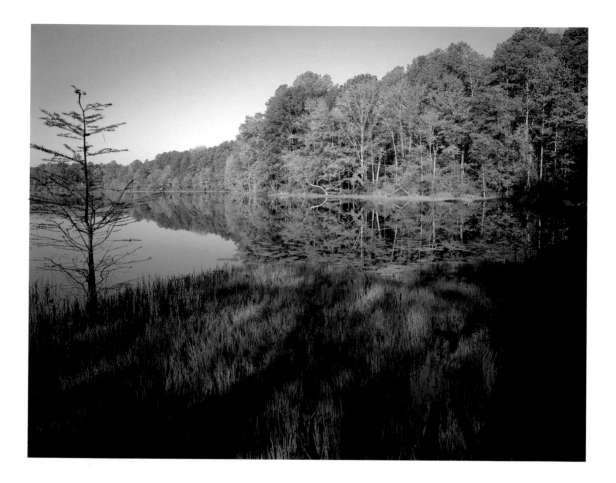

"Let us permit nature to have her way:
she understands her business better than we do."

— Montaigne, *Essays III*

Hot Springs Canyon, Big Bend National Park

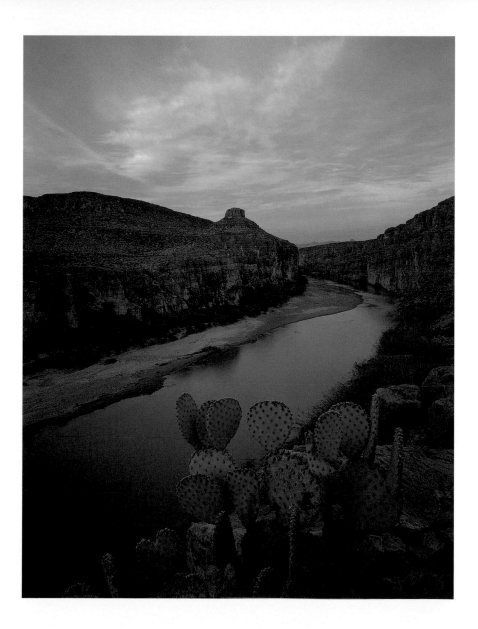

"What would the world be, one bereft
Of wet and of wildness? Let them be left,
O let them be left, wildness and wet;
Long live the weeds and wilderness yet."

— Gerard Manley Hopkins, *Inversnaid*

Cattails, Brazoria National Wildlife Refuge

Overleaf: Aerial view at sunrise, South Padre Island

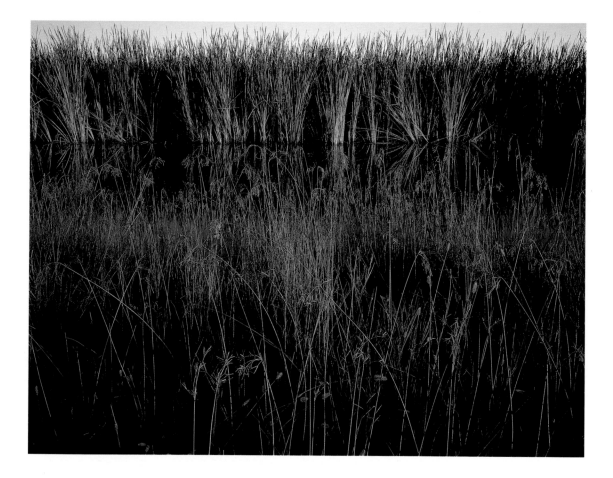

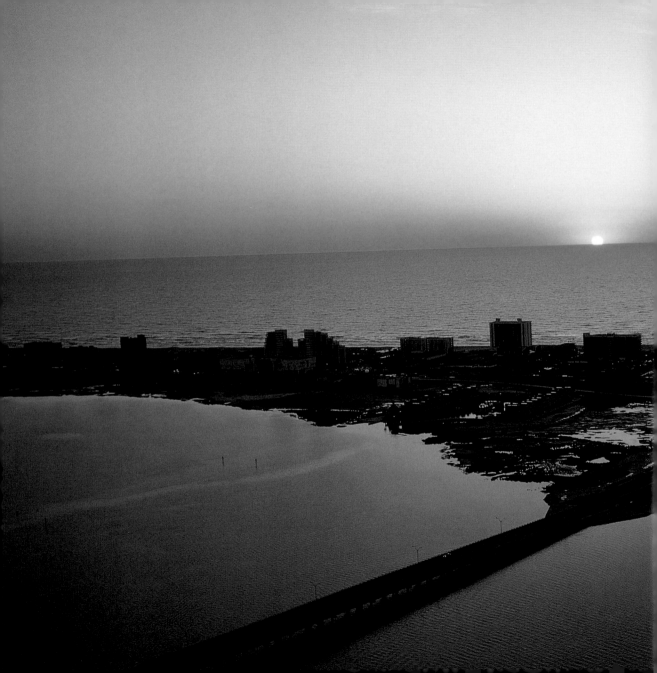

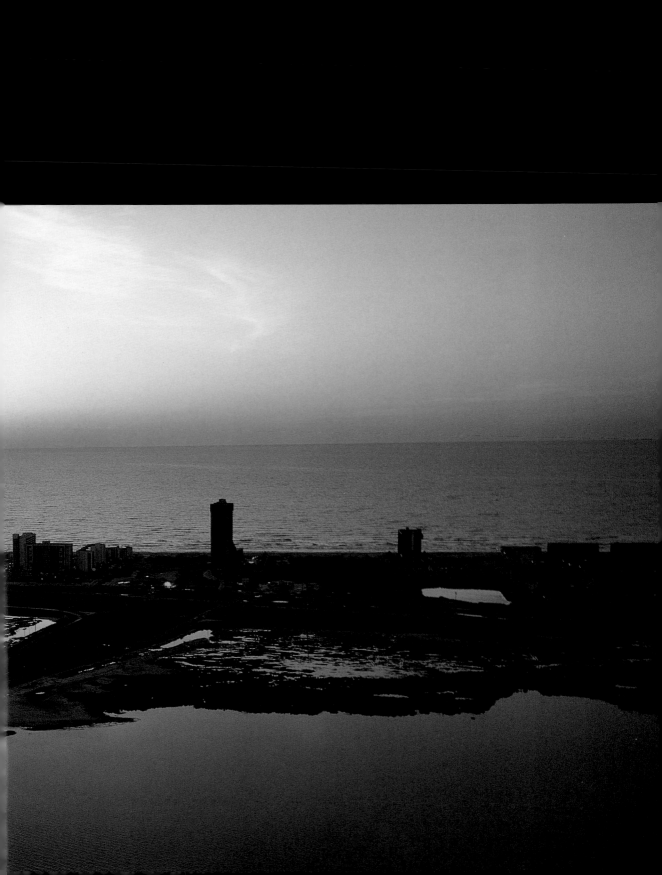

"Come forth into the light of things,

Let Nature be your Teacher."

— William Wordsworth, *The Tables Turned*

Autumn colors, Daingerfield State Park

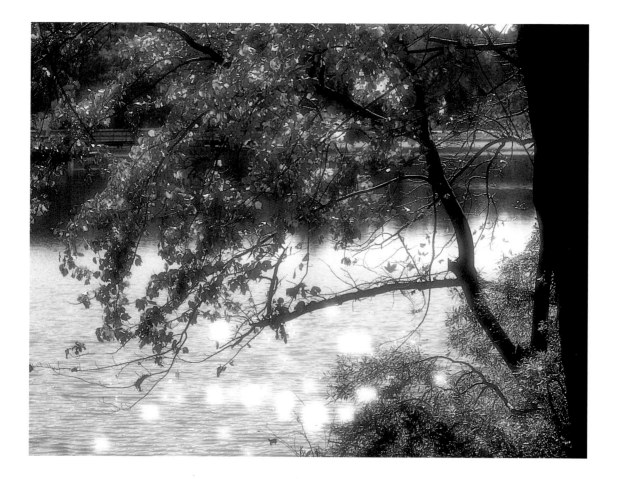

"We need the tonic of wildness...
We can never have enough of nature
We must be refreshed by the sight of inexhaustible vigor,
vast and titanic features..."

— Henry David Thoreau, *Walden*

The Rio Grande, Santa Elena Canyon, Big Bend National Park

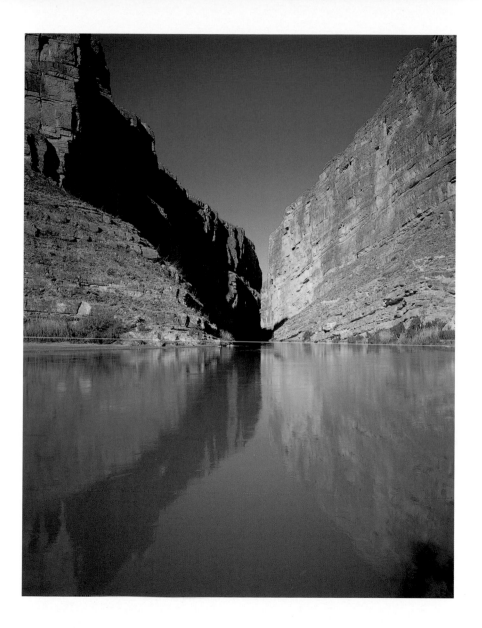

"Everybody needs beauty as well as bread, places to play in and pray in where Nature may heal and cheer and give strength to the body and soul alike."

— John Muir, *Travels in Alaska*

Dawn, South Padre Island

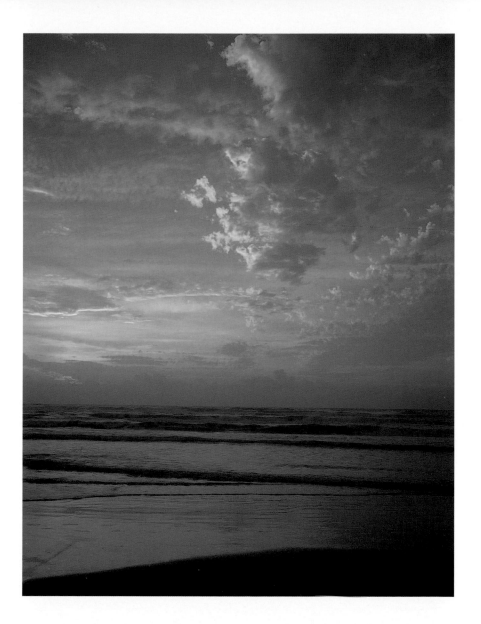

"Everything that happens happens as it should,
and if you observe carefully,
you will find this to be so."

— Marcus Aurelius, *Meditations*

Lake Daingerfield, Daingerfield State Park

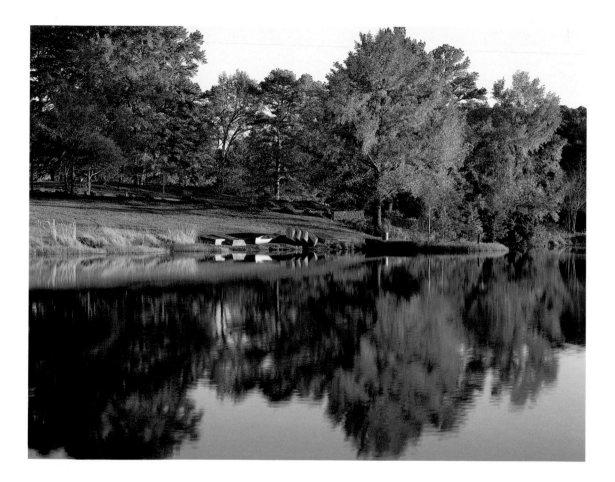

"In Nature's infinite book of secrecy,
A little I can read."

— William Shakespeare, *Antony and Cleopatra*

Rushing waters, McKinney Falls State Park

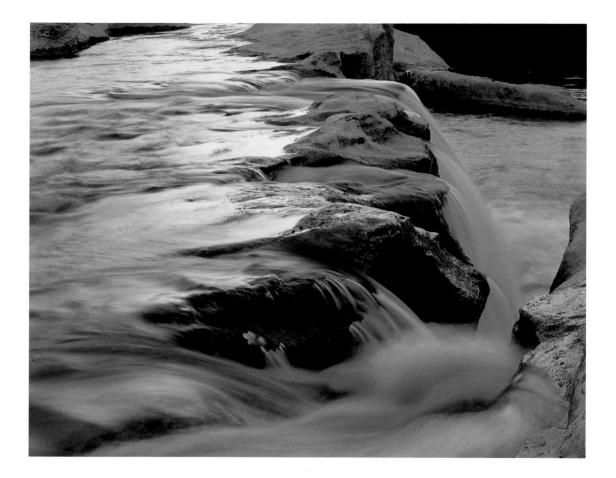

"To see a World in a Grain of Sand
And a Heaven in a wild flower,
Hold Infinity in the palm of your hand
And Eternity in an hour."

— William Blake, *Auguries of Innocence*

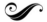

Railroad vines, South Padre Island

"Now I see the secret of the making of the best
persons. It is to grow in the open air,
and to eat and sleep with the earth."

— Walt Whitman, *Leaves of Grass*

Fall foliage, Daingerfield State Park

Overleaf: Salt marsh, Padre Island National Seashore

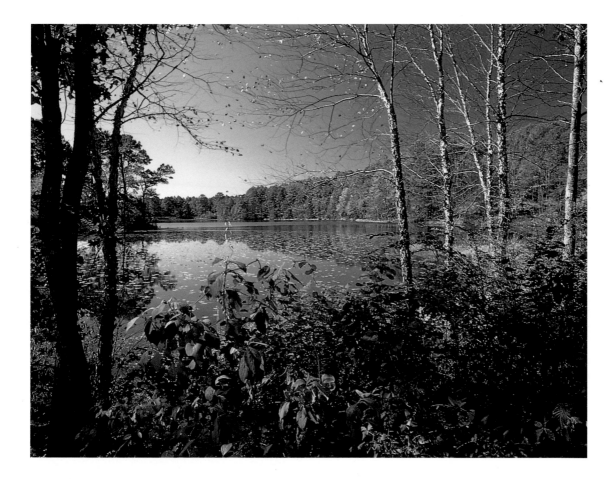

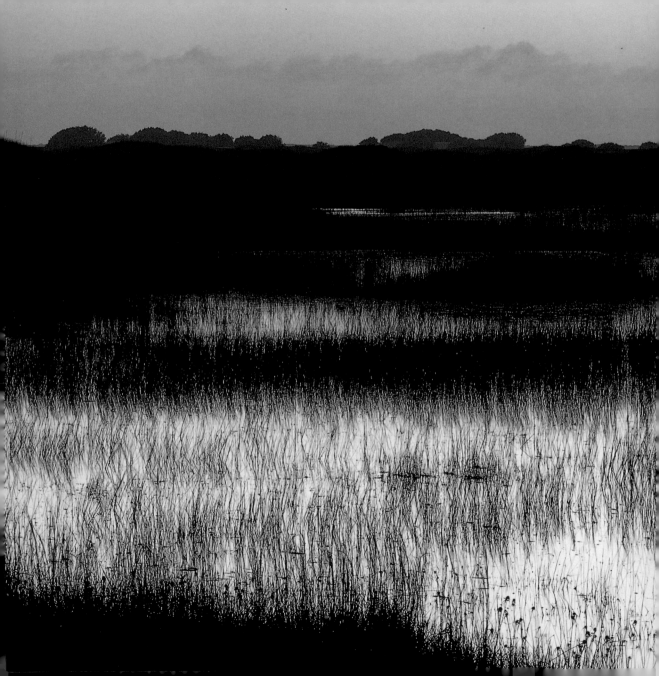

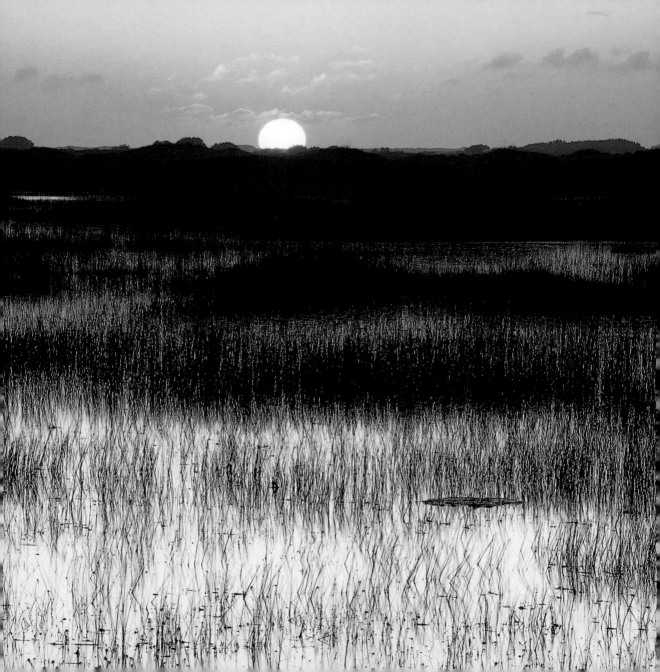

"And forget not that the earth delights to feel
your bare feet and the winds long to
play with your hair."

— Kahlil Gibran, *The Prophet*

Seagulls, Padre Island National Seashore

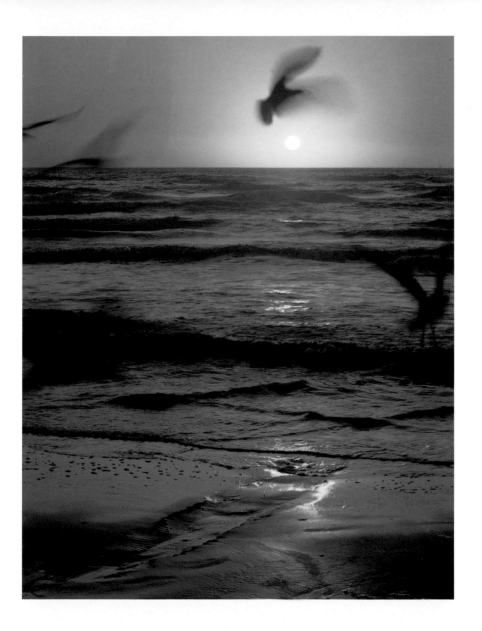

"The visible marks of extraordinary…
power appears so plainly in all the works of
creation that a rational creature who will but
seriously reflect on them cannot miss the
discovery of a deity."

— John Locke,
*An Essay Concerning Human Understanding*

❧

North Fork of the Guadalupe River, Kerr County

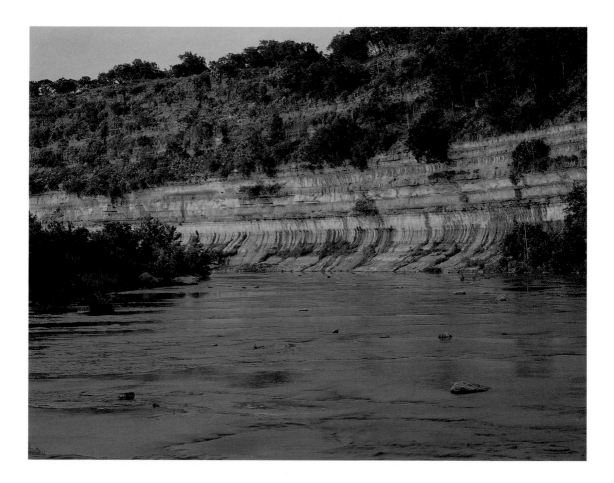

"For in and out, above, about, below,
'Tis nothing but a Magic Shadow-show,
Played in a Box whose Candle is the Sun,
Round which we Phantom Figures come and go."

— Omar Khayyam, *Rubaiyat*

Cypress trees, Caddo Lake State Park

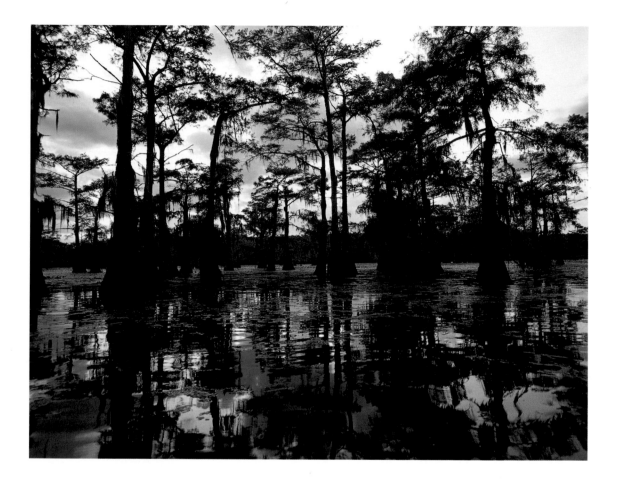

"Solitude…is essential to any depth of
meditation or of character; and solitude in the
presence of natural beauty and grandeur,
is the cradle of thoughts and aspirations…"

— John Stuart Mill, *Principles of Political Economy*

Colors of dusk reflected in surf, Chambers County

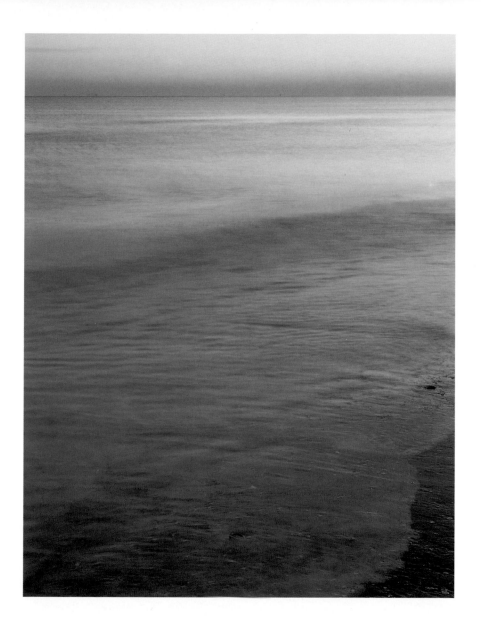

"Surely there is something in the unruffled calm of nature that overawes our little anxieties and doubts; the sight of the deep-blue sky...seems to impart a quiet to the mind."

— Jonathan Edwards,
*The New Dictionary of Thoughts*

❧

Cypress trees in Caddo Lake, Caddo Lake State Park

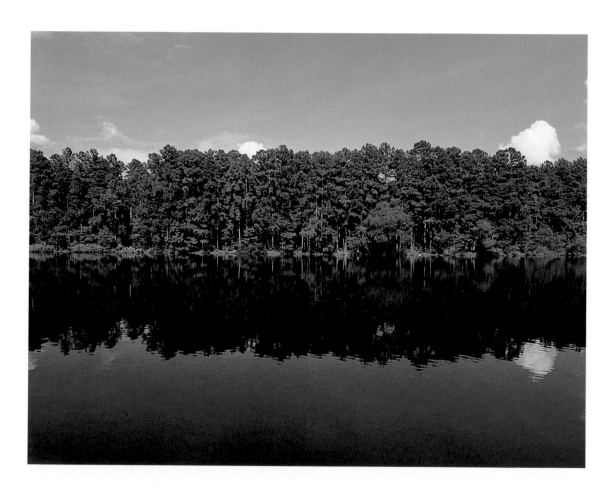

"We do not receive wisdom,
we have to discover it for ourselves
by a voyage that no one can take for us…"

— Marcel Proust, *Remembrance of Things Past*

Shrimp boat, Padre Island National Seashore

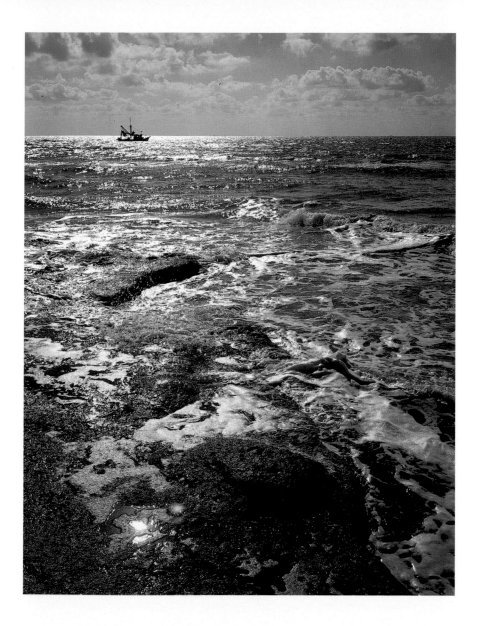

"There is a road from the eye to the heart that does not go through the intellect."

— G. K. Chesterton, *The Defendant*

Sunset reflections, Medina County

Overleaf: Autumn hues and lily pads, Daingerfield State Park

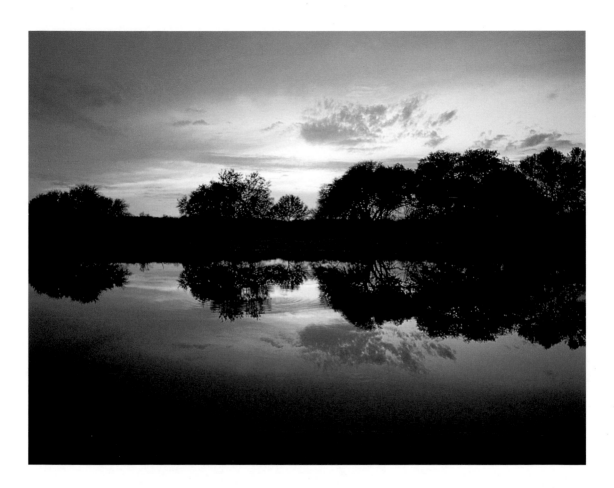

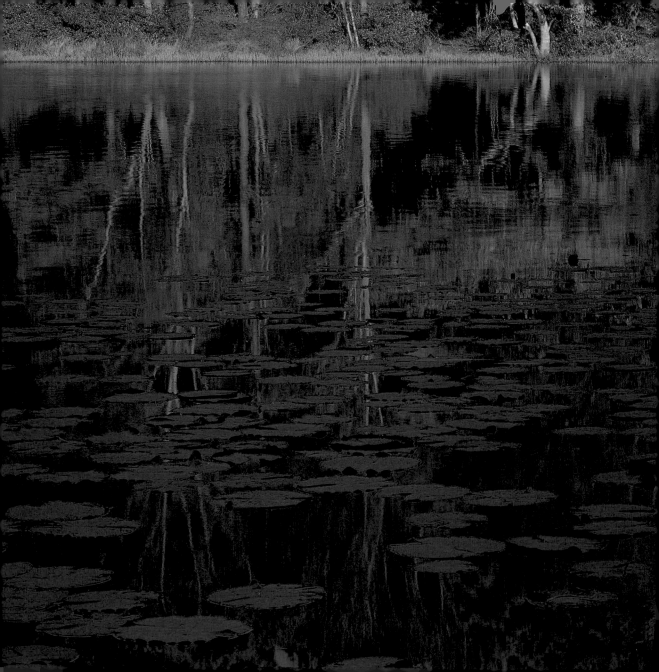

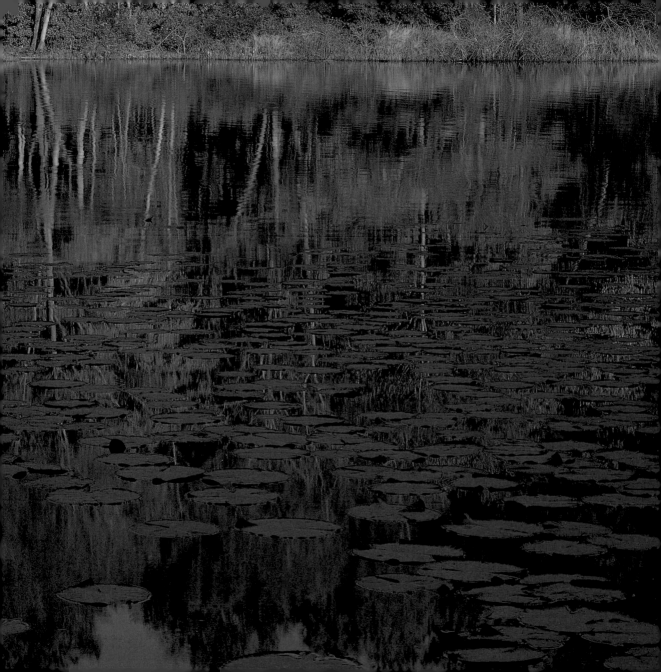

"The whole secret of the study of nature lies in
learning how to use one's eyes...."

— George Sand, *Nouvelles Lettres d'un Voyageur*

Dawn on the Gulf of Mexico, Chambers County

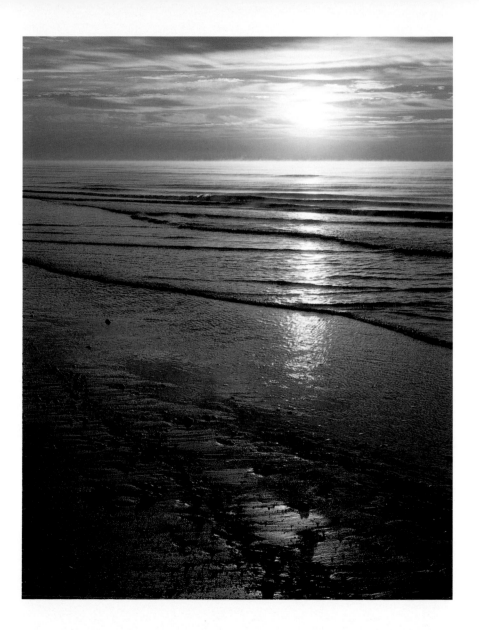

"How often we forget all time, when lone
Admiring Nature's universal throne
Her woods, her wilds, her waters intense
Reply of hers to our intelligence."

— Lord Byron, *The Island*

The Rio Grande, Big Bend Ranch State Natural Area

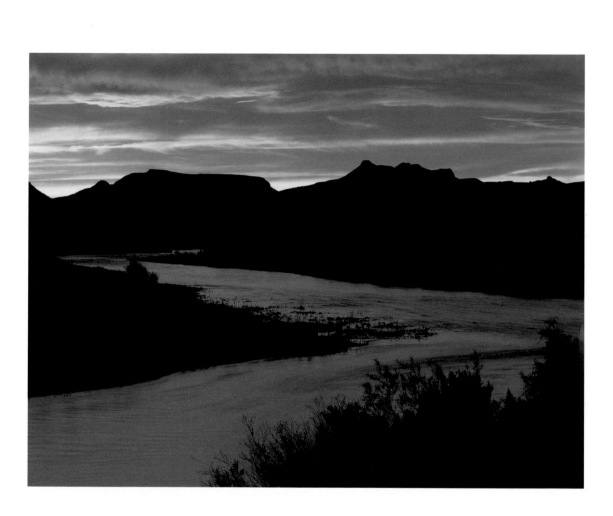

"Nature is shy and noncommittal in a crowd.
To learn her secrets, visit her alone or
with a single friend, at most."

— Montaigne, *Essays III*

❧

Cypress trees in fall colors, Caddo Lake State Park

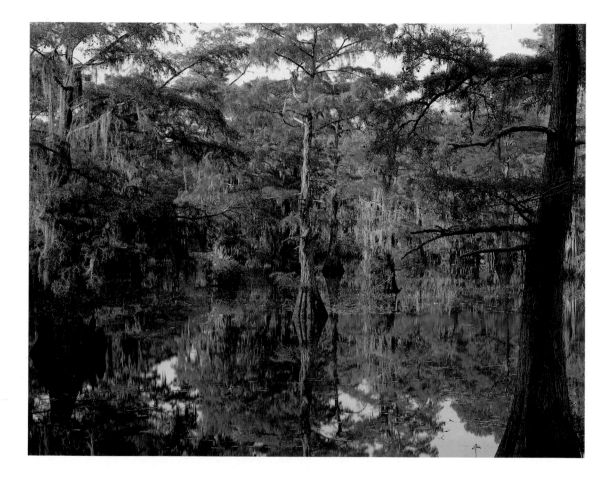

"To the attentive eye, each moment of the year
has its own beauty…it beholds, every hour,
a picture which was never seen before,
and which shall never be seen again."

— Ralph Waldo Emerson, *Beauty*

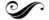

Colors of sunset, Barton Creek, Travis County

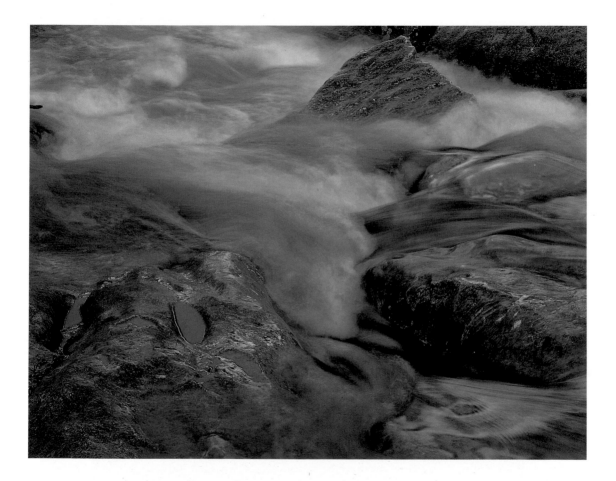

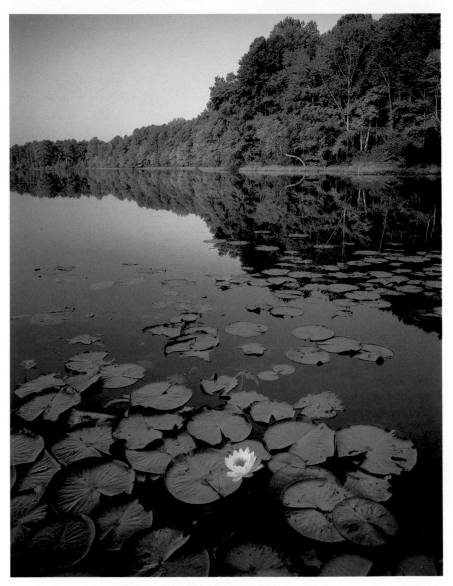

Water lily, Daingerfield State Park